By Art Mobb

illustrations by Michael Farhat

Any reference contained in this book to athletes does not constitute or imply their endorsements.

Copyright © 2021 Michael Farhat
All rights reserved.

Dedicated to
Layla & Nathan Farhat

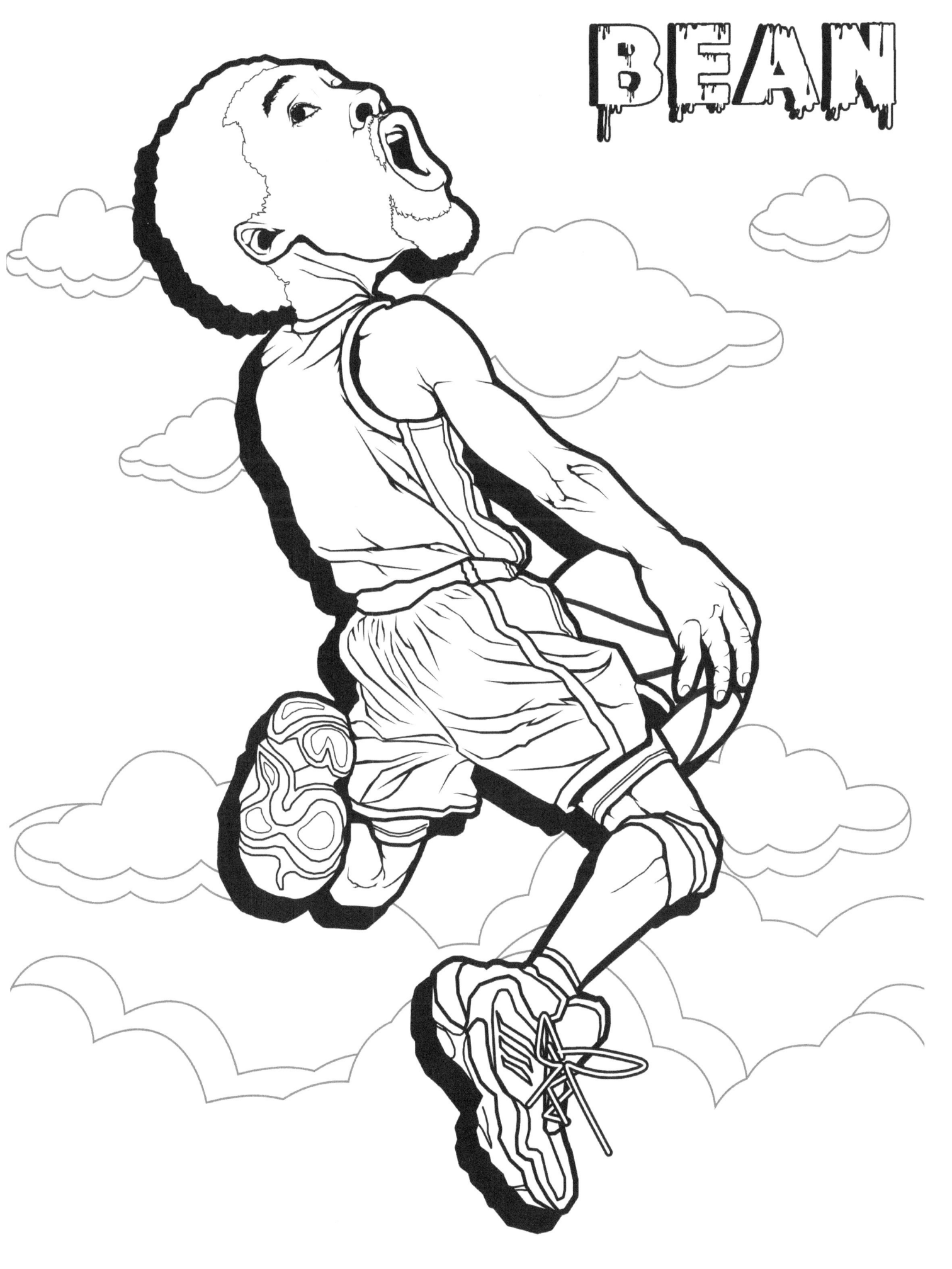

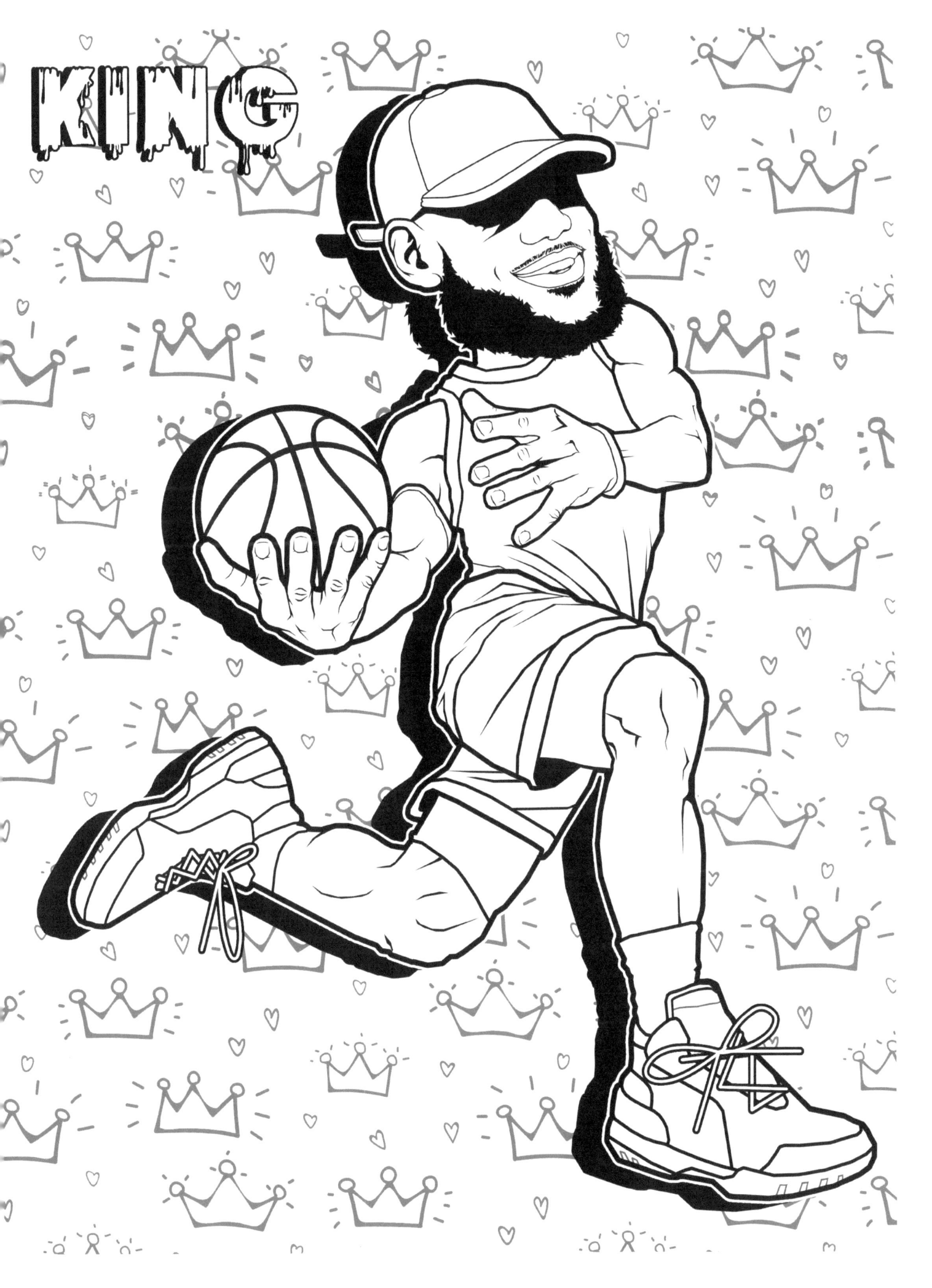

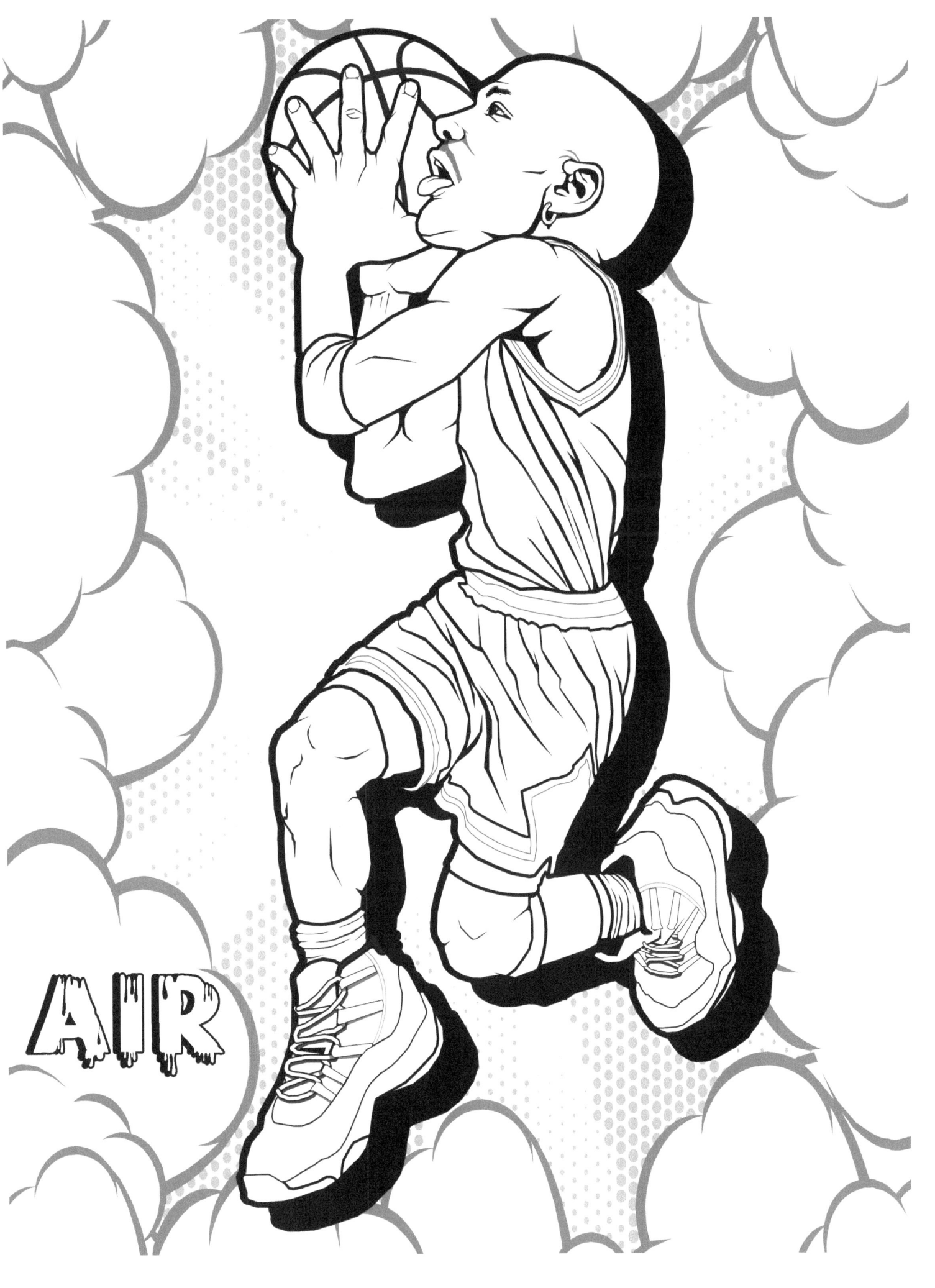

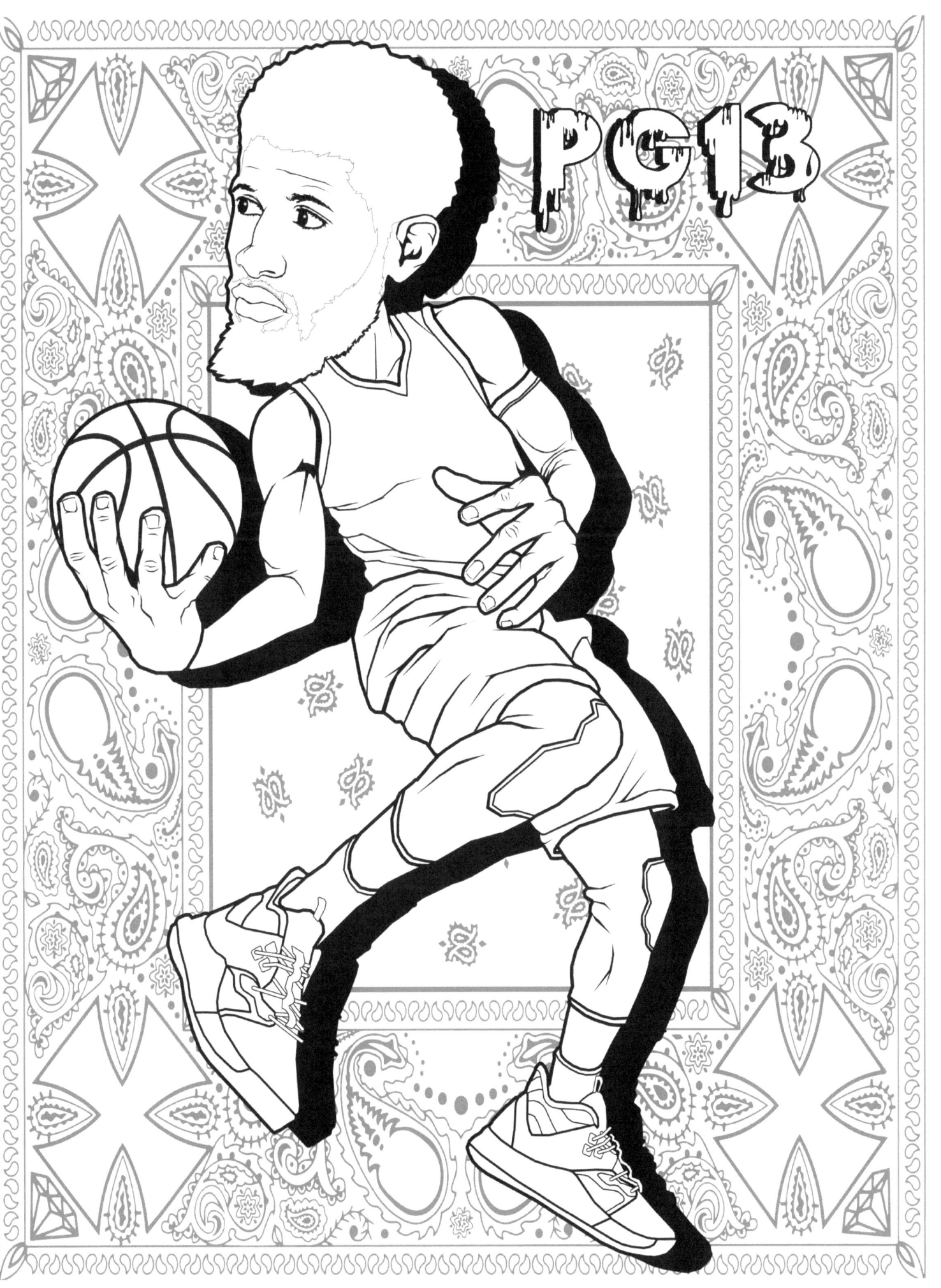

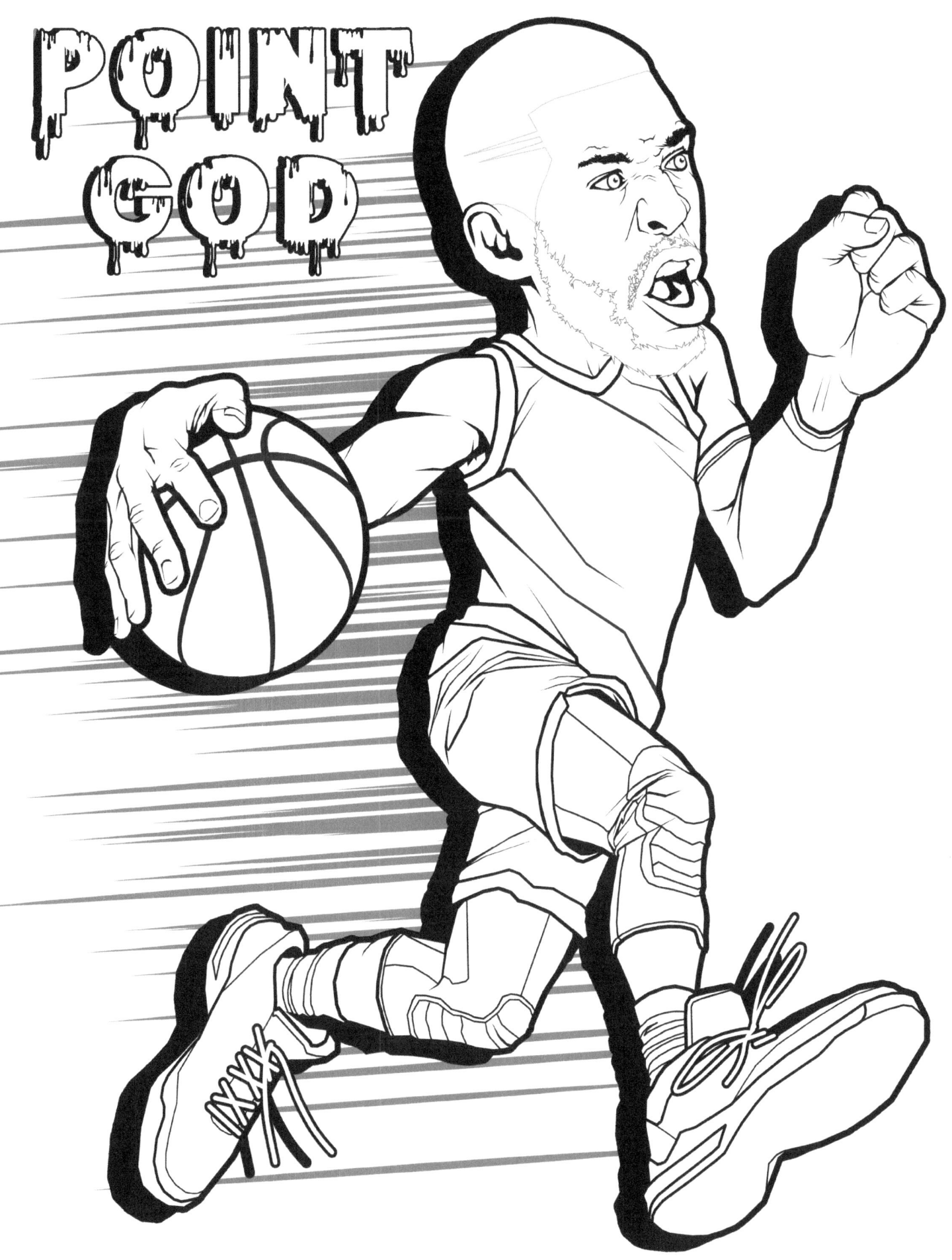

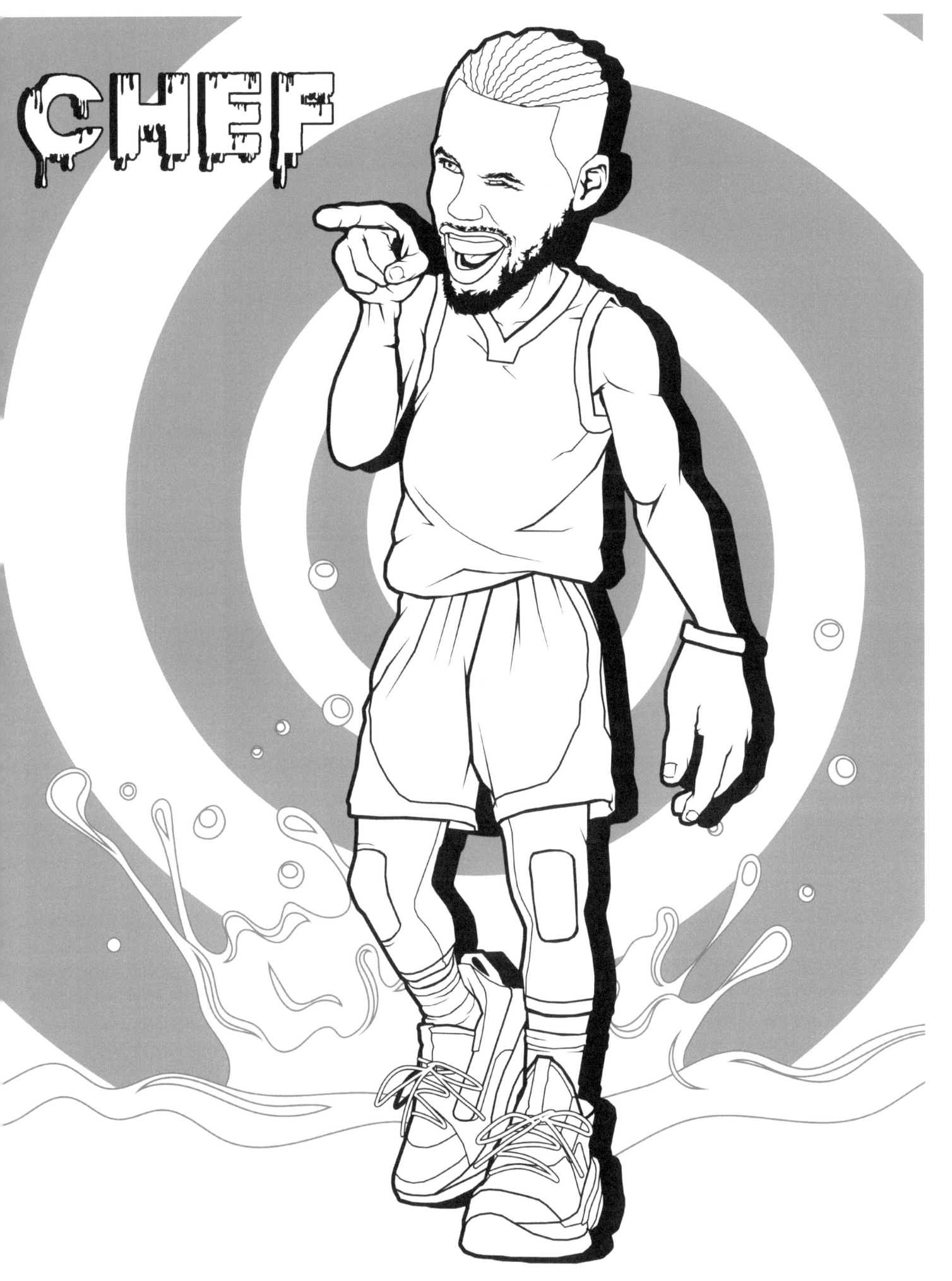

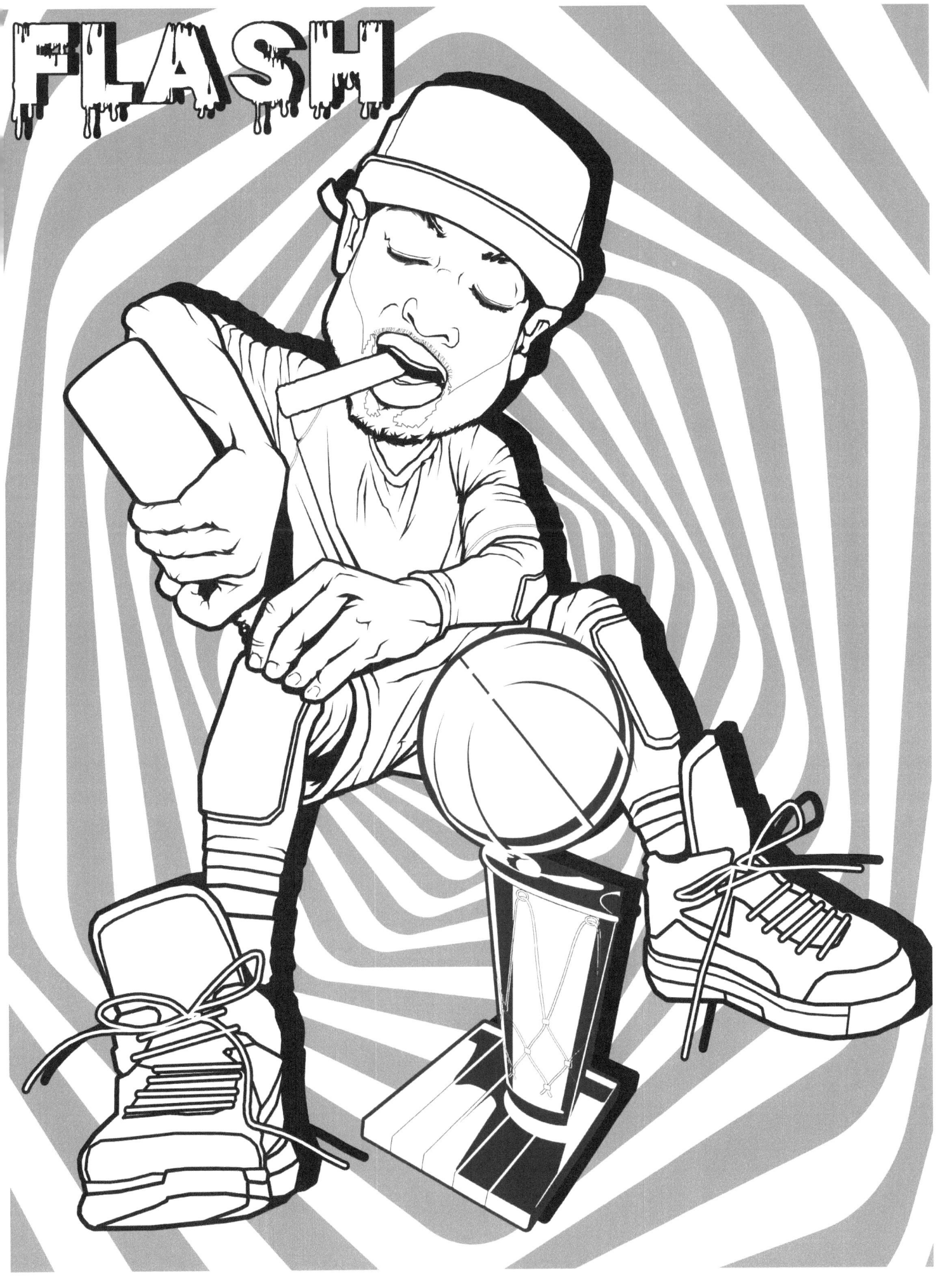

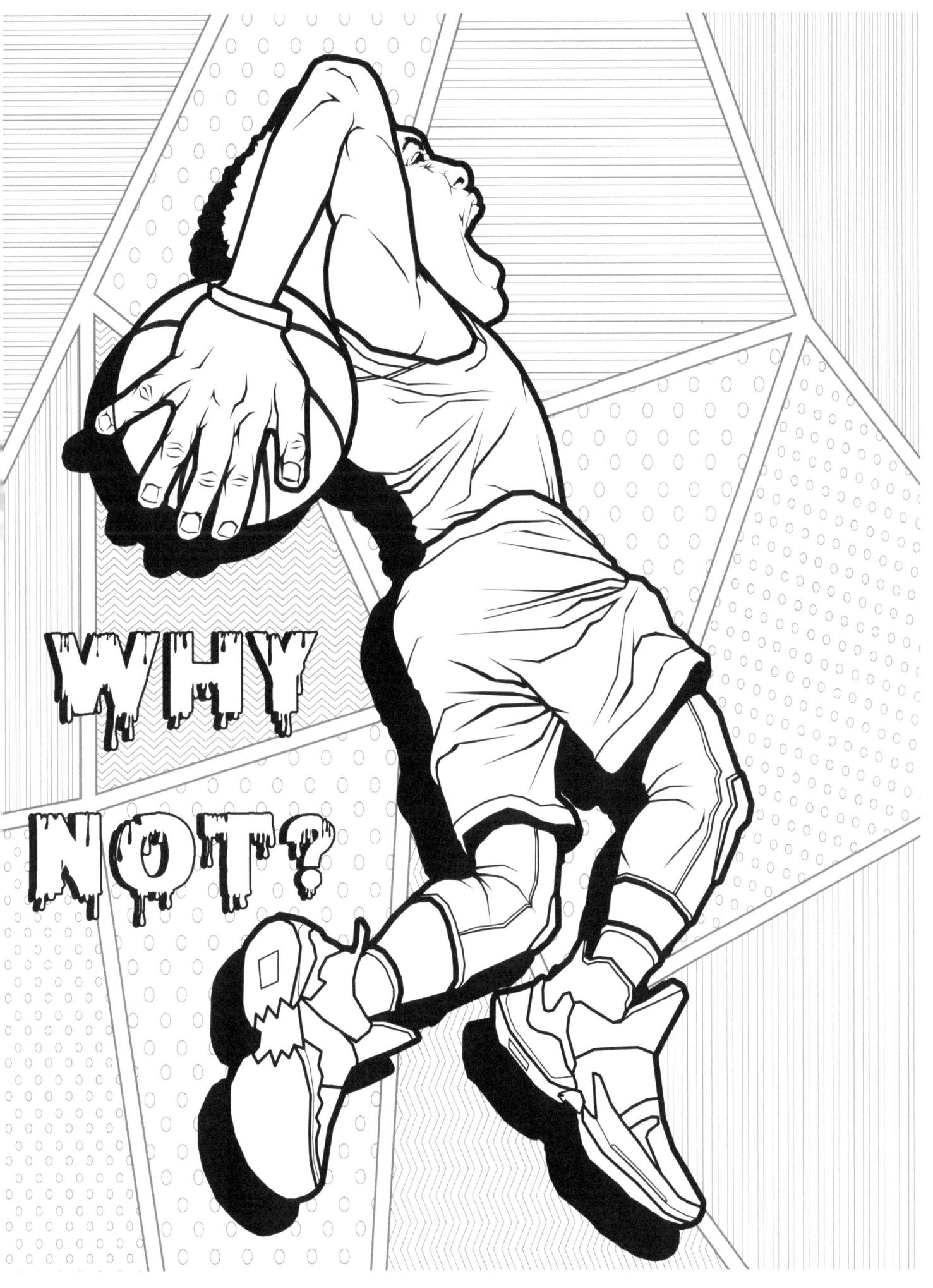

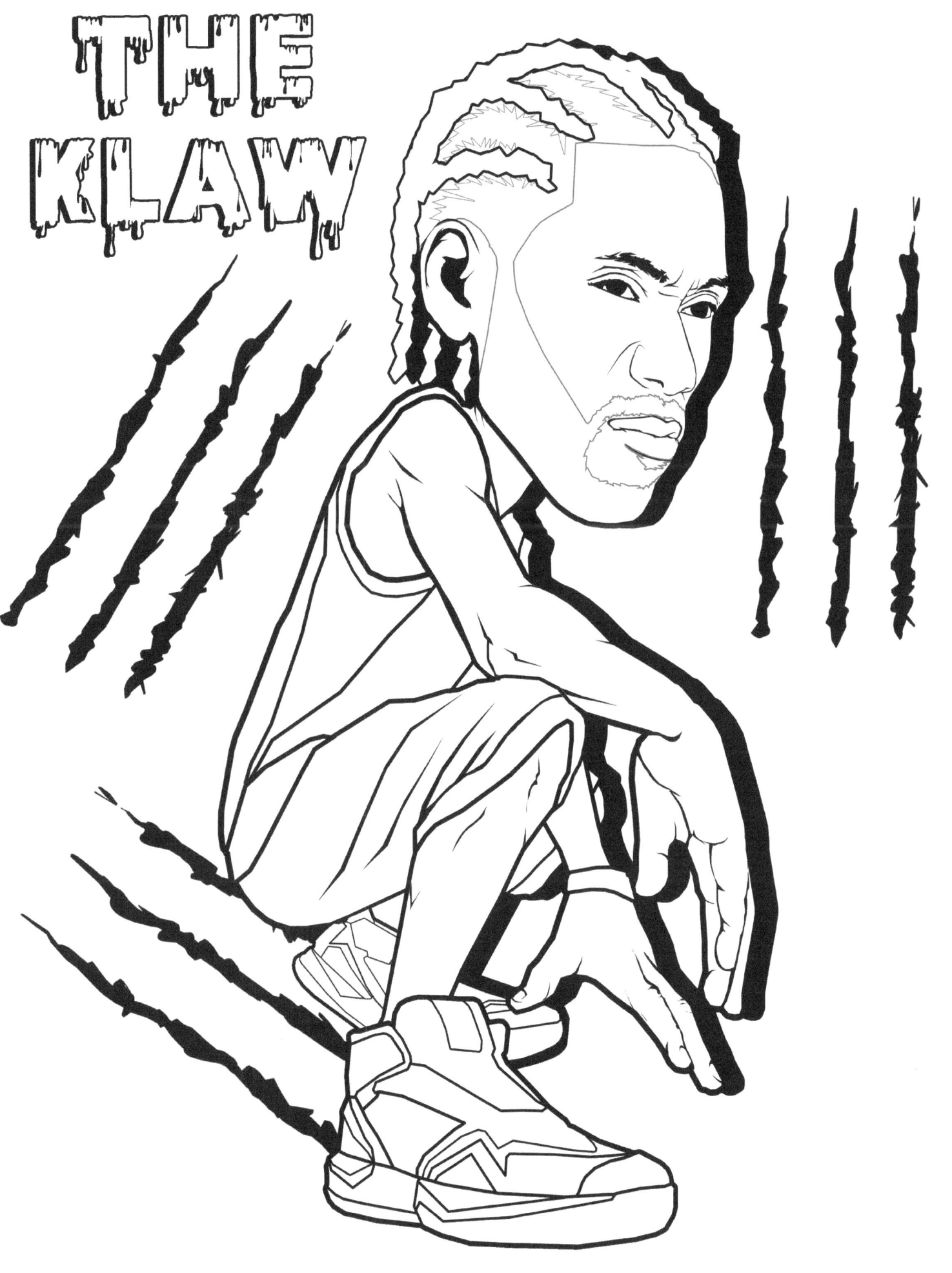

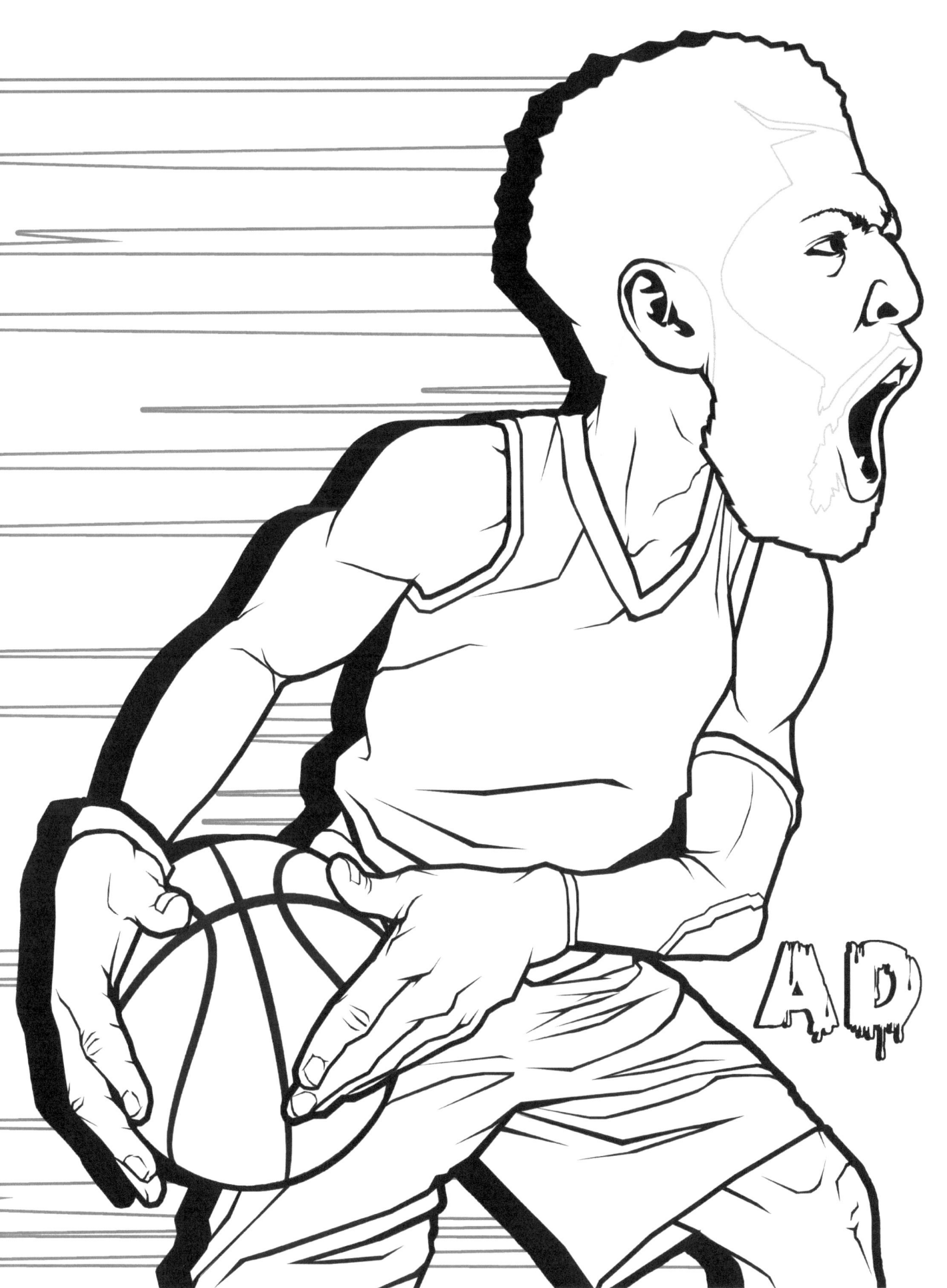

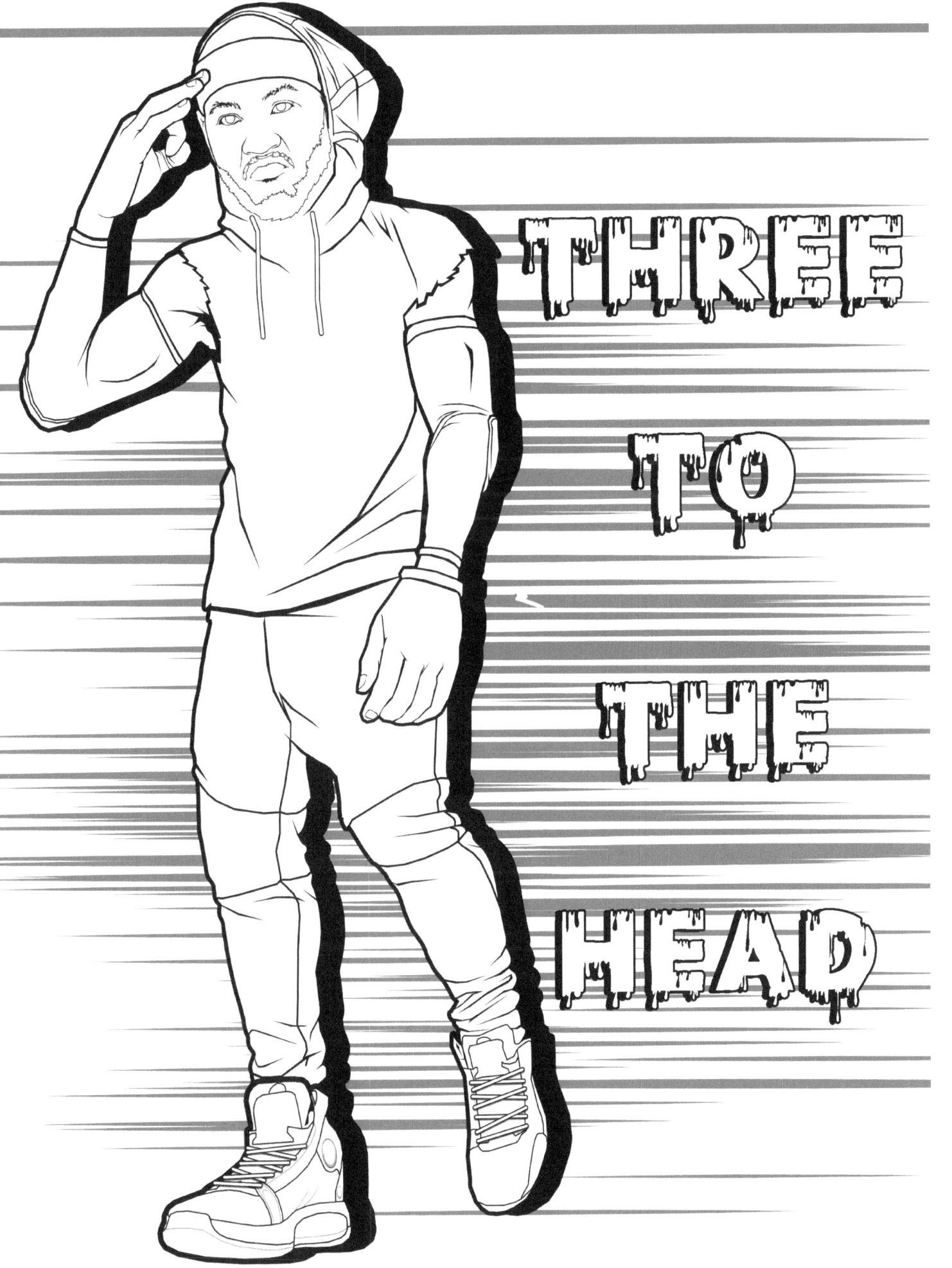

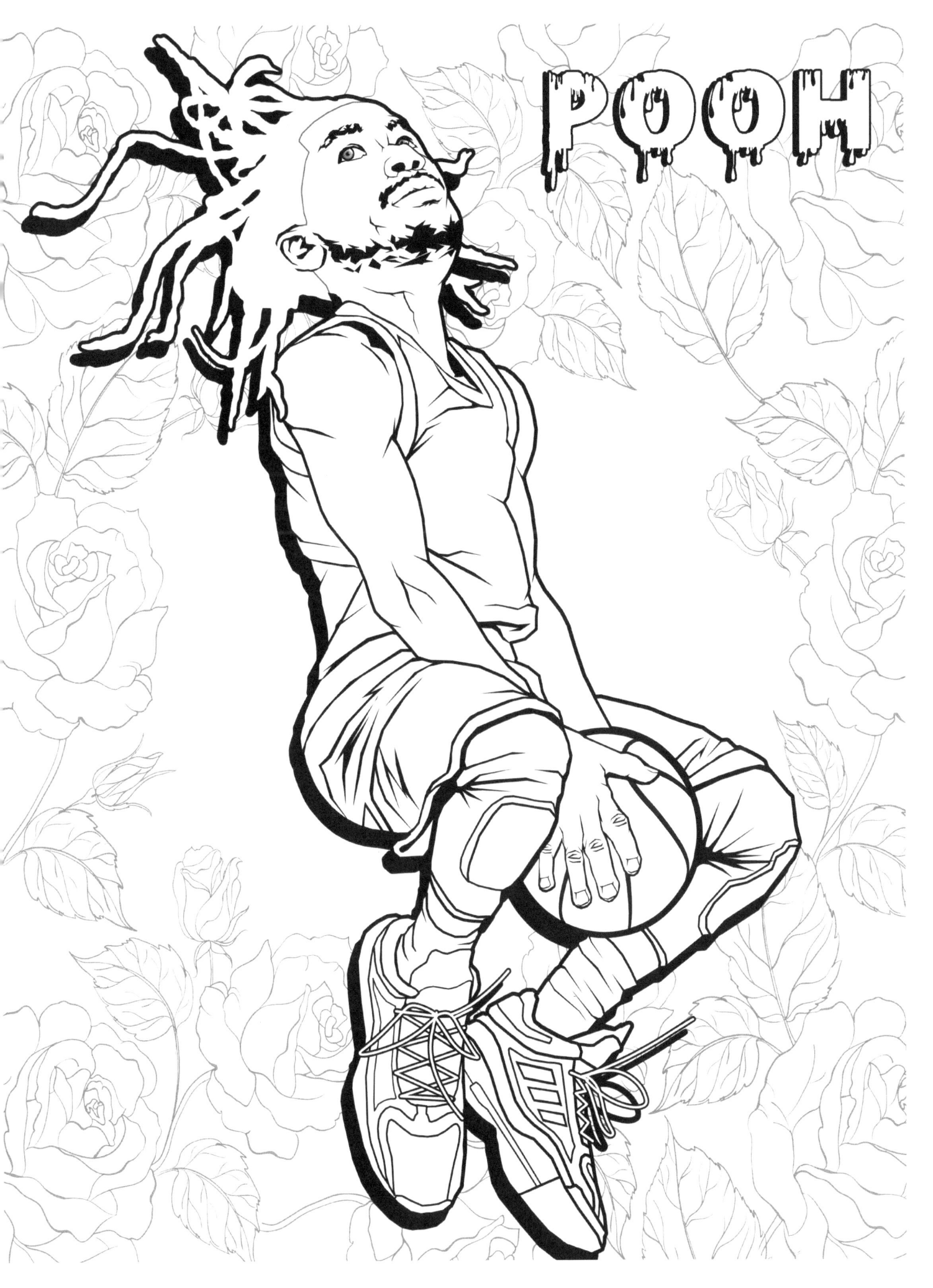

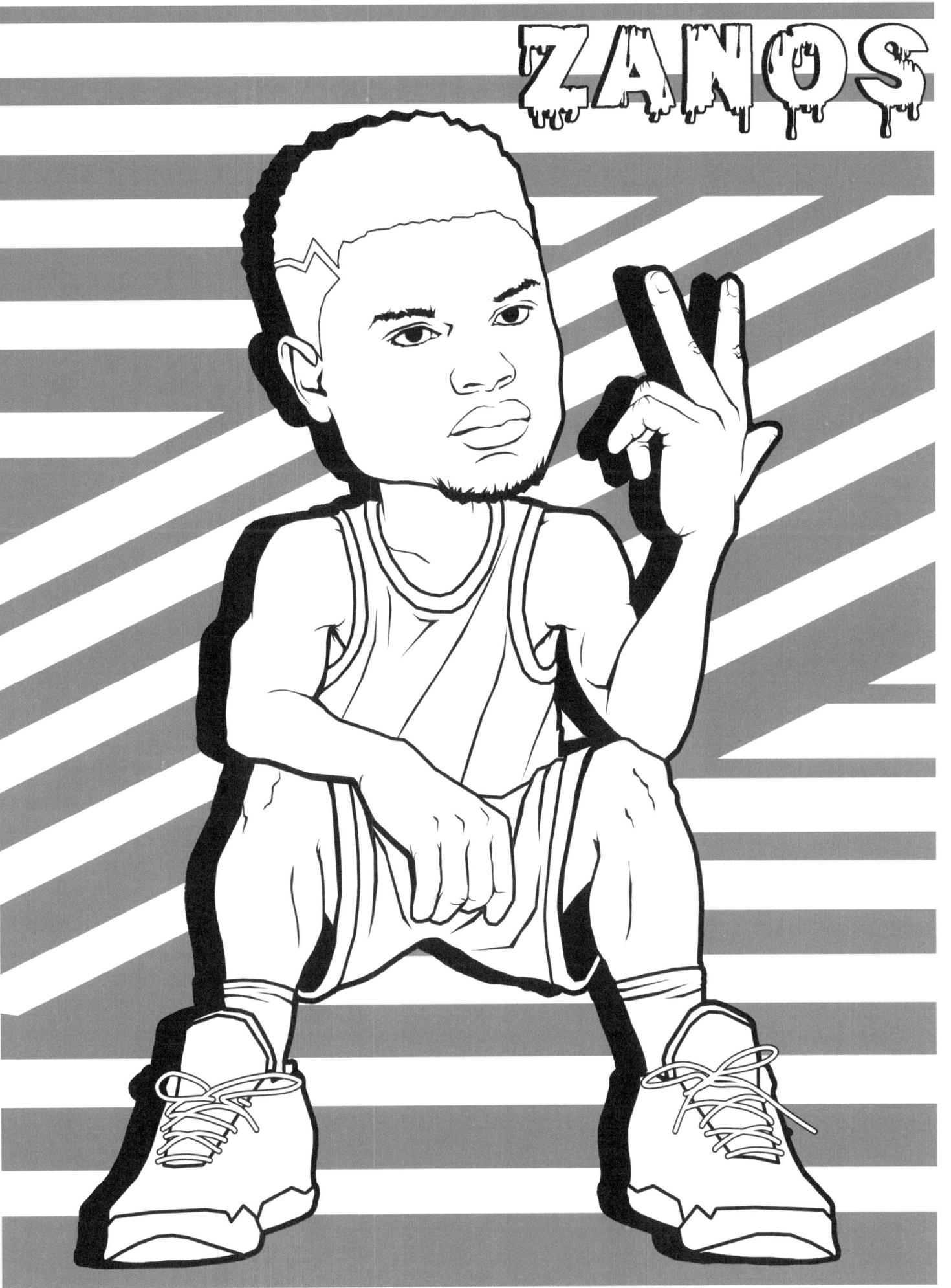

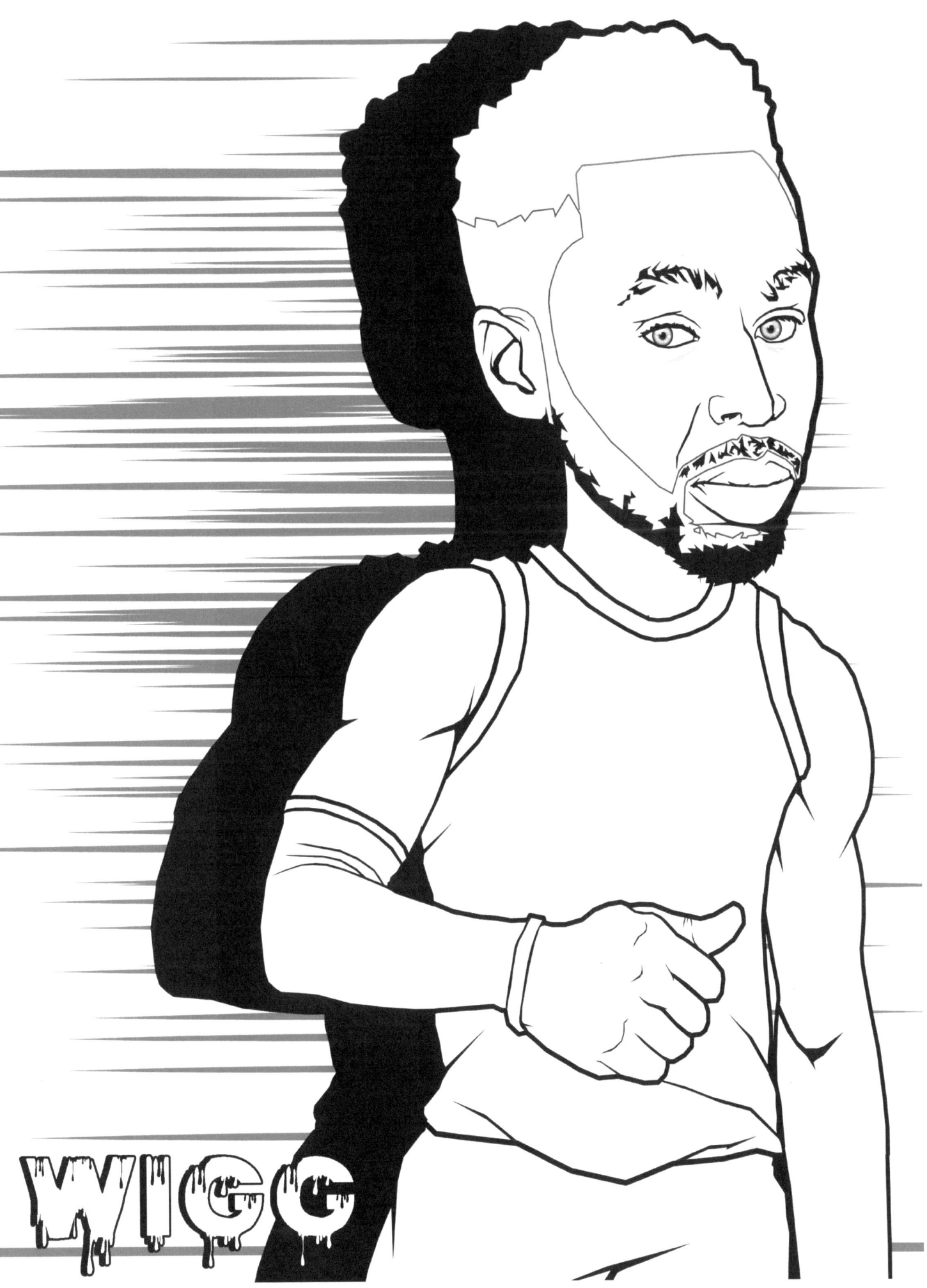

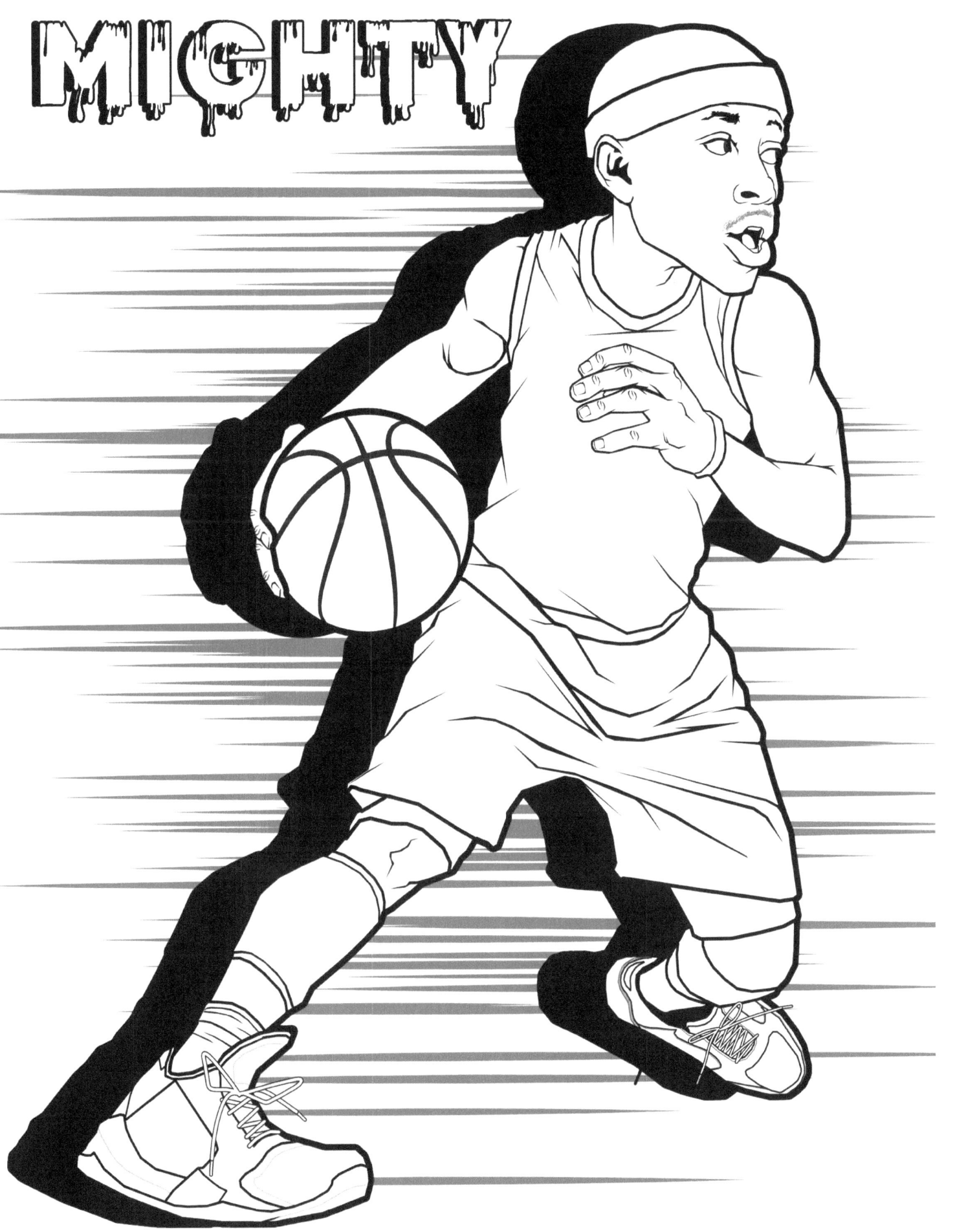

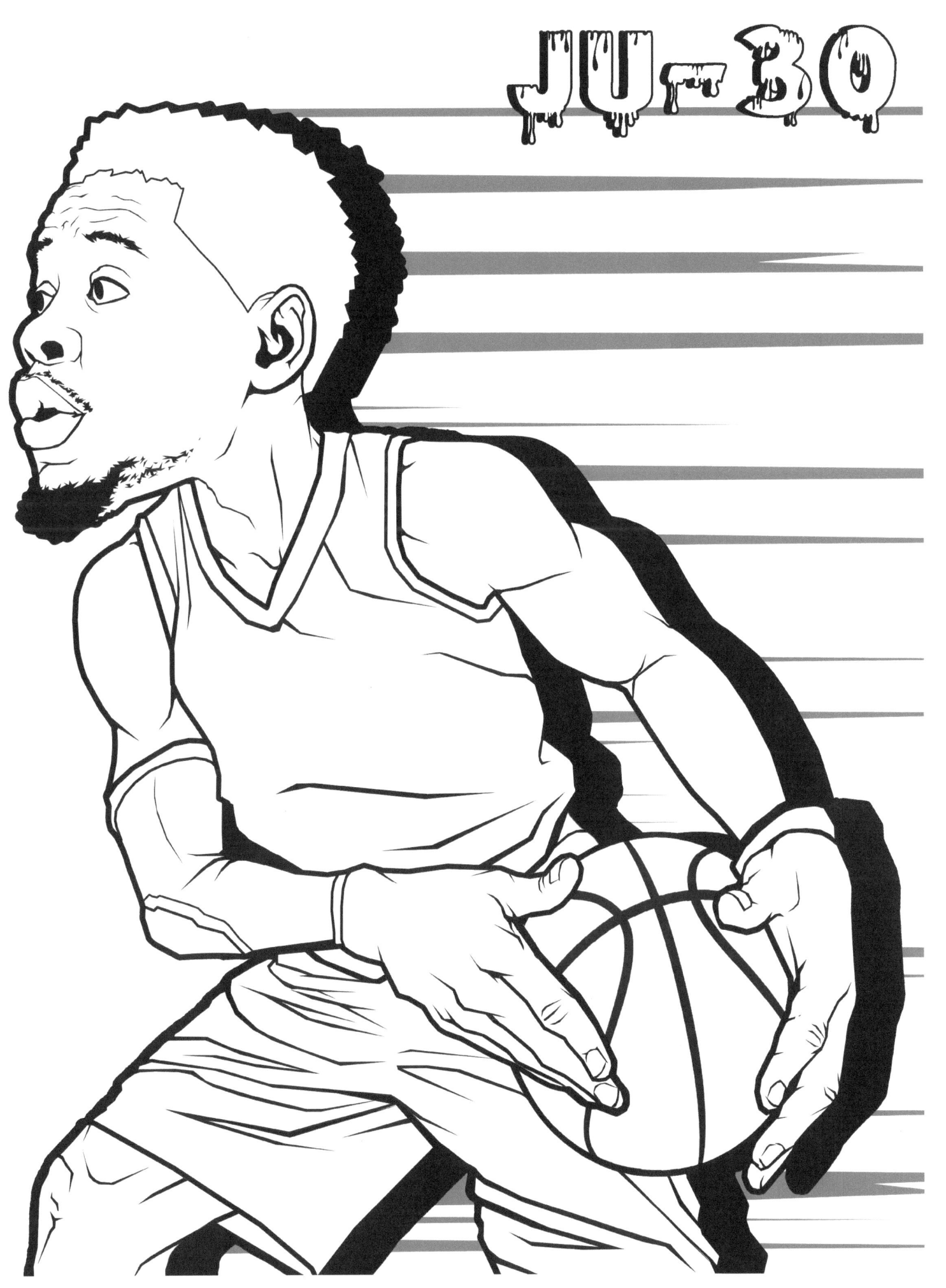

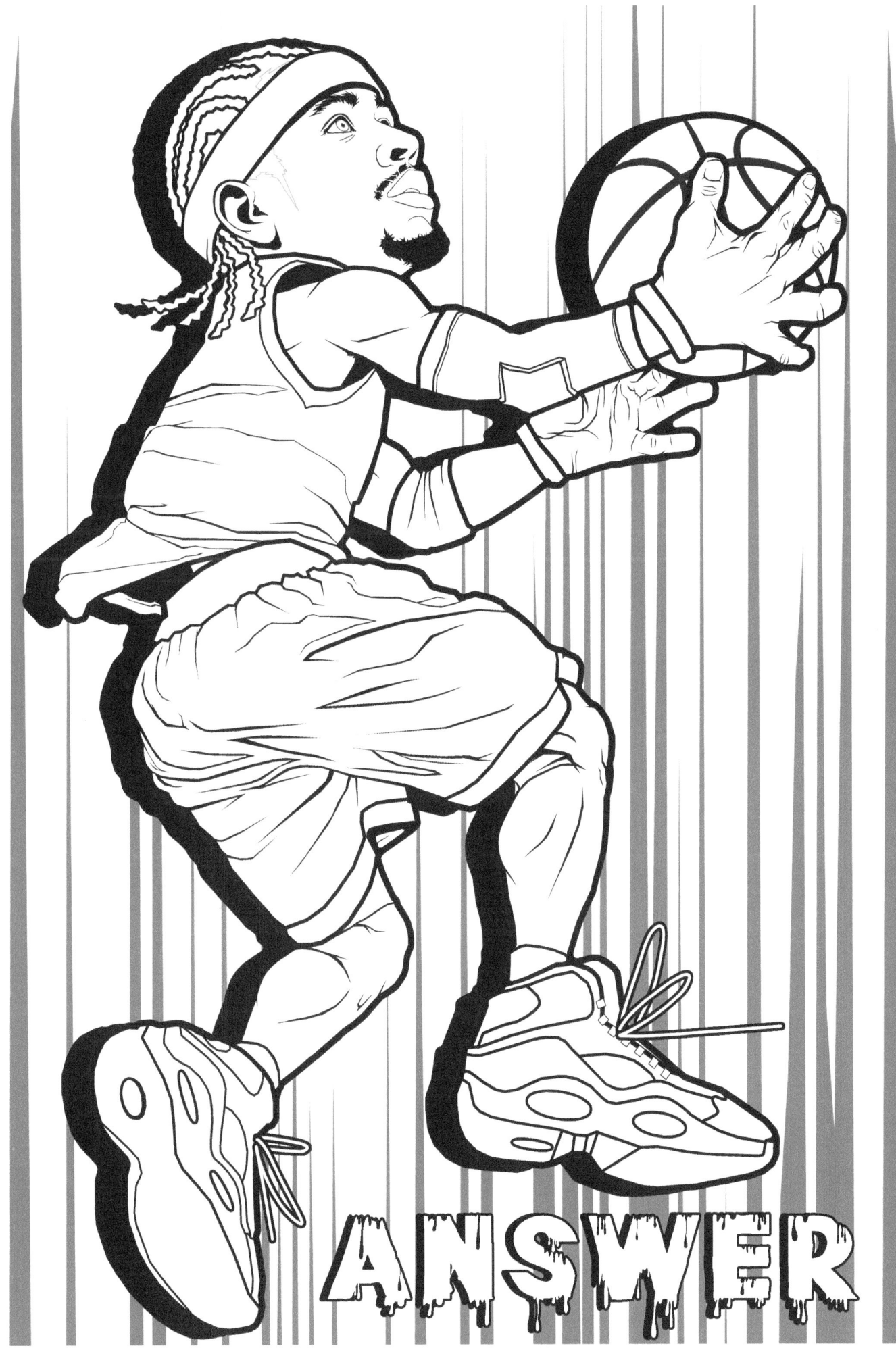

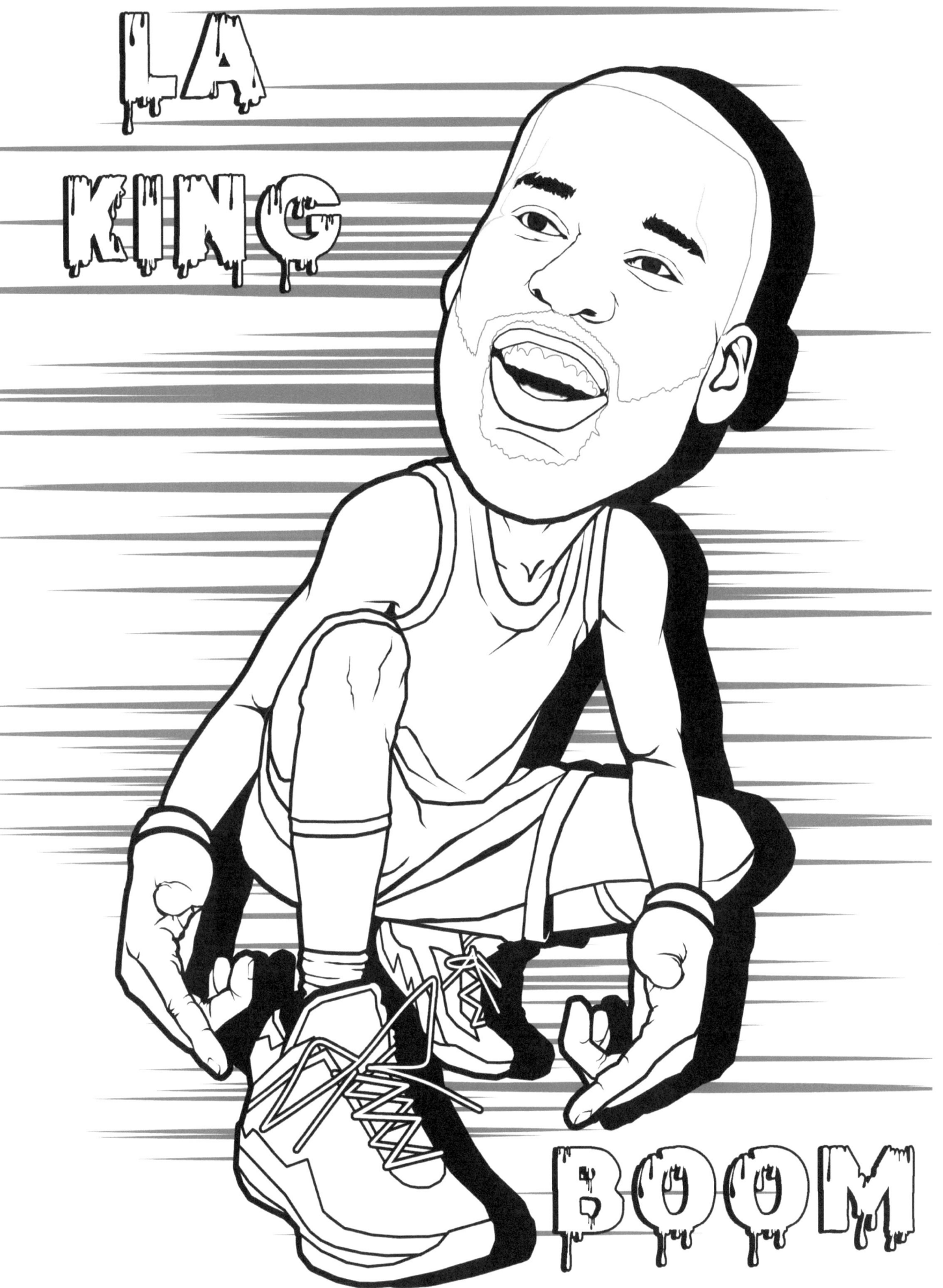

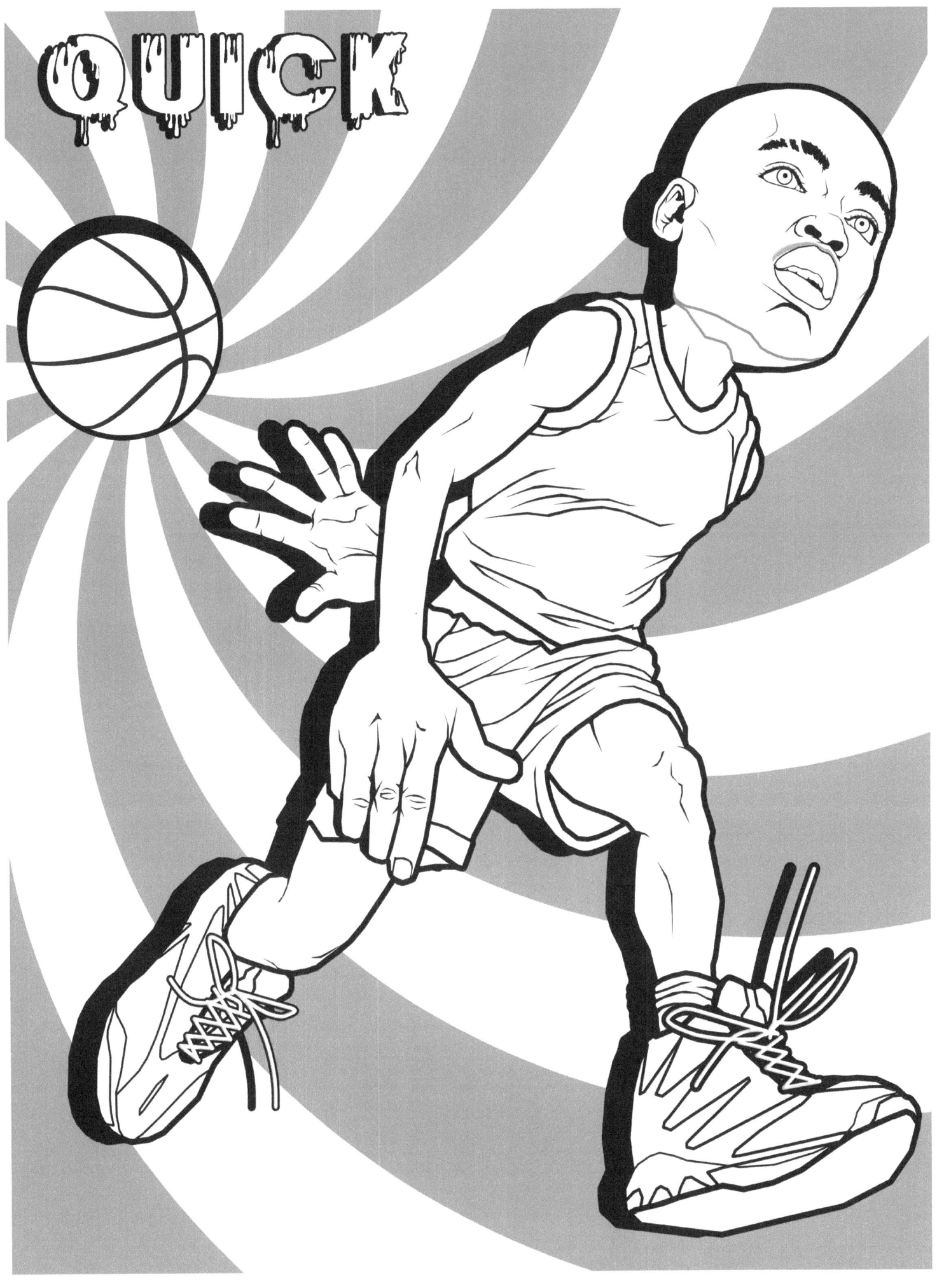

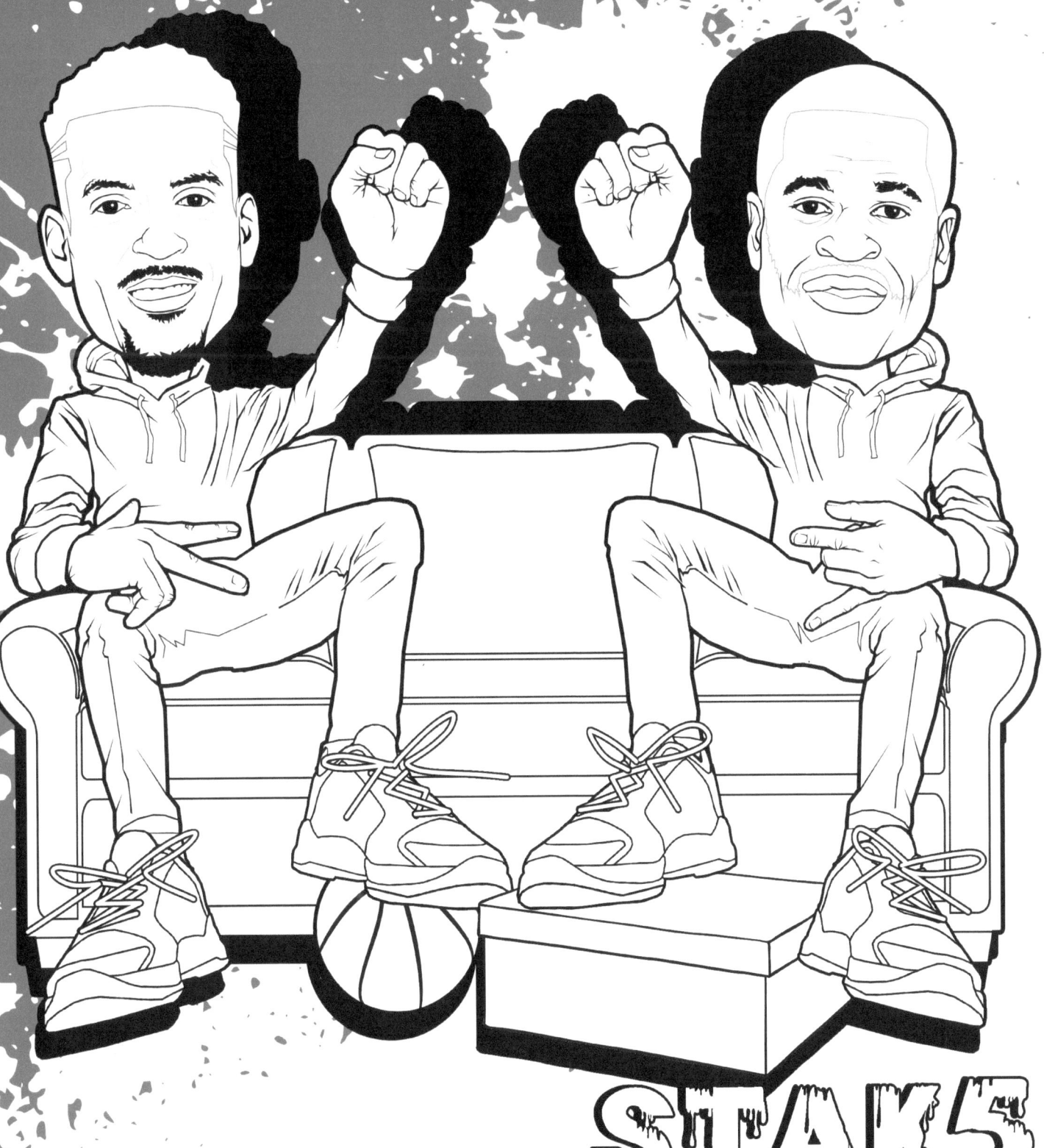

THIS BOOK BELONGS TO

Copyright © 2021 Michael Farhat
All rights reserved.

www.ingramcontent.com/pod-product-compliance
Lightning Source LLC
Chambersburg PA
CBHW051046180526
45172CB00002B/542